SOVIET
POSTERS

From the collection of
Sergo Grigorian

Introduction and descriptions by
Maria Lafont

Prestel

Munich London New York

The Russian Revolution, which took place on 7th November 1917, was without doubt one of the most significant events of the twentieth century. It saw the revolutionaries, or *Bolsheviks,* establish the first communist state. As dictated by the Communist Manifesto, the next step, for them, was to spread the revolution across the world, and one means they had of achieving this aim was through visual propaganda. In Russia, the majority of the population was illiterate at the time of the revolution (over 80% of the country), and using simple yet powerful visual images made spreading ideas more effective. Propaganda posters were displayed everywhere, in factories and offices, on newspaper stands and places where passersby had only had a few seconds in which to grasp their messages — on trams, the walls of buildings and at shop entrances.

The first Soviet propaganda poster appeared shortly after the revolution and they continued to be produced until 1985 when *perestroika*, Mikhail Gorbachev's policy of opening up the Soviet Union, rendered the old-school political propaganda obsolete.

Posters reflected all stages of Soviet history — starting with Lenin's Revolution and the Civil War; they followed the politics of Stalin, widely advertising Five-Year Plans, industrialisation and prosperity. With the beginning of the Second World War, the posters focused entirely on fighting fascism. After the War, they took important topical issues and events as subjects — the Cold War, Vietnam, the Cuban Missile Crisis and the first man in space. The themes covered were not only military or purely political, but also included sports, art, cinema, children, women and family values. They glorified Soviet achievements and extolled its virtues — 'Happy are those born under the Soviet Star!' was the slogan of Stalin's regime. Poster creation was a serious business, often entrusted to the hands of famous painters and graphic designers. Many early posters were produced by prominent artists, including some of the founders of Constructivism and others who employed avant-garde photomontage techniques, such as Alexander Rodchenko and El Lissitzky, whose works raised the humble political poster from propaganda to high art.

Produced in varying quantities, ranging from a few hundred to thousands, the total annual production of posters could be more than a million. However, over time, many became rare. Generally small, rarely exceeding A1-sized sheets, they were displayed on the streets in snow and rain, and more often than not they were simply thrown away when new ones came out. Some were destroyed as a result of last-minute decisions by the censorship committee, with a few examples miraculously surviving, set aside by the producers at their own risk. Owing to this disposable nature, a few marks and blemishes may be seen on the high resolution scans of original posters reproduced in this book. Rather than detract from their beauty, we hope it adds to their authenticity.

Today, these beautiful artworks have become collectibles, which continue to inspire contemporary artists and designers in the creation of their own works of art and advertising. Furthermore, these posters also help us to see many of the most significant political and social events of the twentieth century from a different perspective, the one from the other side of the Iron Curtain. The works selected for this book represent some of the best examples of propaganda posters from various stages of the history of the Soviet Union and are a solid introduction into one of the most extensive and extraordinary private collections of soviet posters in the world, that held by Sergo Grigorian.

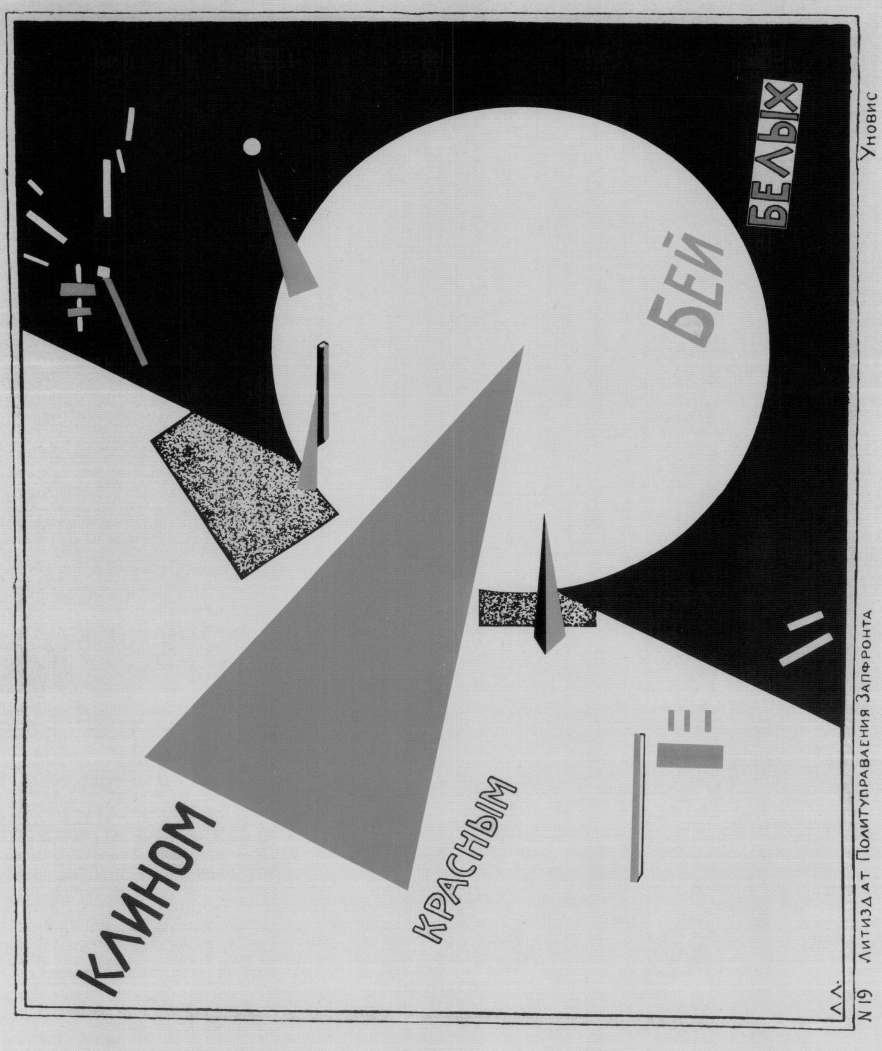

ARTIST
Lissitzky L. M.

TITLE
Beat the Whites with the Red Wedge

YEAR
1919

SIZE
48.3 × 68.7 cm

Produced in 1919, *Beat the Whites with the Red Wedge* is one of the most significant and best-known works of art of the period. It was created by Lazar Lissitzky, better known as El Lissitzky, a pupil of Kazimir Malevich and one of the most important artists of the Soviet era. El Lissitzky made it during the civil war and only a few original examples still exist. Using an innovative, constructivist style, he experiments with texts, fonts, colours and geometry — creating a new art form. He depicts the impending victory of the (Bolshevik) Red Army, symbolised by a red wedge, over the (anti-communist) White Army, pictured as a white circle. The red wedge dramatically and forcefully penetrates the white circle, bringing an end to the civil war and the ultimate victory of the Bolshevik forces.

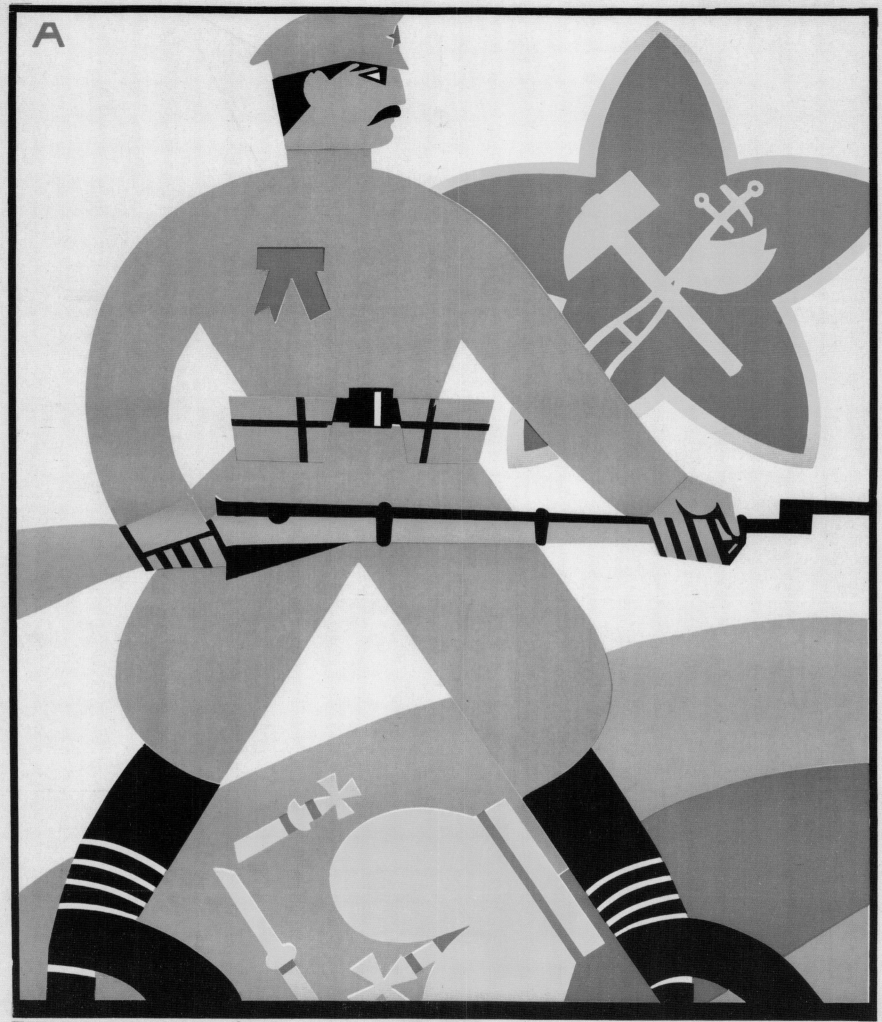

РЕВОЛЮЦИОННЫЙ ДЕРЖИТЕ ШАГ,
НЕУГОМОННЫЙ НЕ ДРЕМЛЕТ ВРАГ.

ARTIST

Petrizky A.

TITLE

**Keep Your Revolutionary Step, a Restless Enemy
Does Not Sleep**

YEAR

1919

SIZE

93 × 71 cm

This beautiful and colourful avant-garde poster dates from during the civil war. A soldier marches through the streets with the crown and sceptre of the Tsar under his feet, symbolising the fall of the imperial regime, while the red star with a hammer and sickle, symbolising Communism, is pictured shining high in the sky. The title of the poster, *Keep Your Revolutionary Step, a Restless Enemy Does Not Sleep*, comes from the poem *The Twelve* by Aleksandr Blok. Composed by Blok in cold and hungry revolutionary Petrograd, it tells of twelve soldiers, who symbolise the twelve apostles, marching in snow through the windy city. The poem praises the revolution and denounces the bourgeois past. Within a few years of writing the poem, Blok had become disillusioned with the Revolution; gravely ill, forbidden by Lenin from leaving the country and without any means of making a living, he died in 1921.

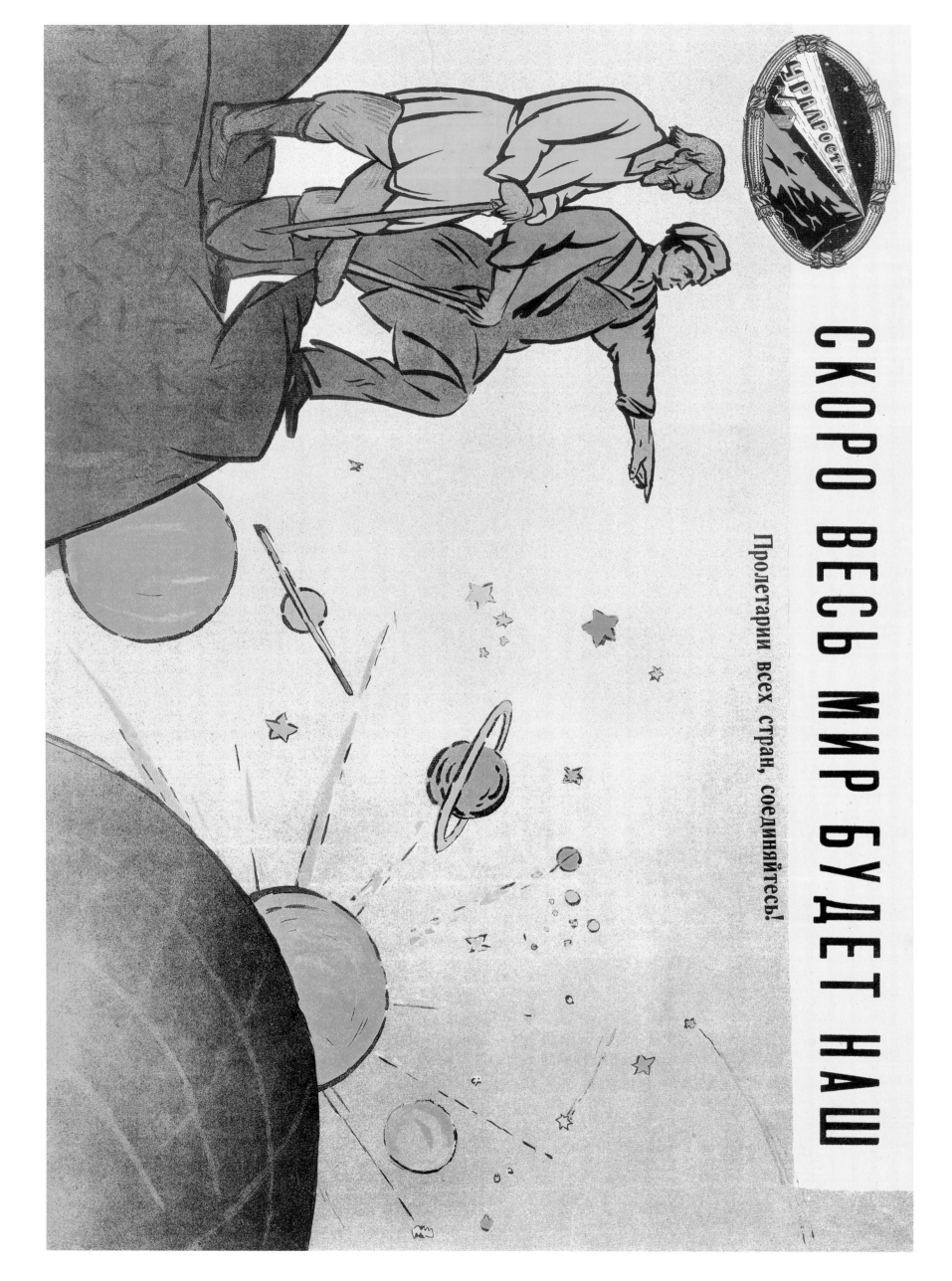

ARTIST

Sayanskii L. V.

TITLE

Soon the Whole World Will Be Ours.
Workers of All Countries, Unite!

YEAR

1919

SIZE

36 × 53 cm

Produced in 1919, this poster is a remarkable historical document; it shows that two years after the revolution, not only did the Soviet government and its people believe that the world was ready to revolt, but that the whole universe would eventually be communist. Believing that their comrades across the world were eager to have a revolution in their own countries, they considered the victory over the entire planet an imminent accomplishment; the next step would be to conquer the whole universe. Such ideas were based on studies by Konstantin Tsiolkovsky, a Soviet rocket scientist and one of the first to advocate human space exploration and travel to Mars. Sayanskii masterfully represents these ideas, depicting a Russian worker and a peasant dominating the earth, observing the rest of the planets within our solar system becoming communist, with Russia leading the movement.

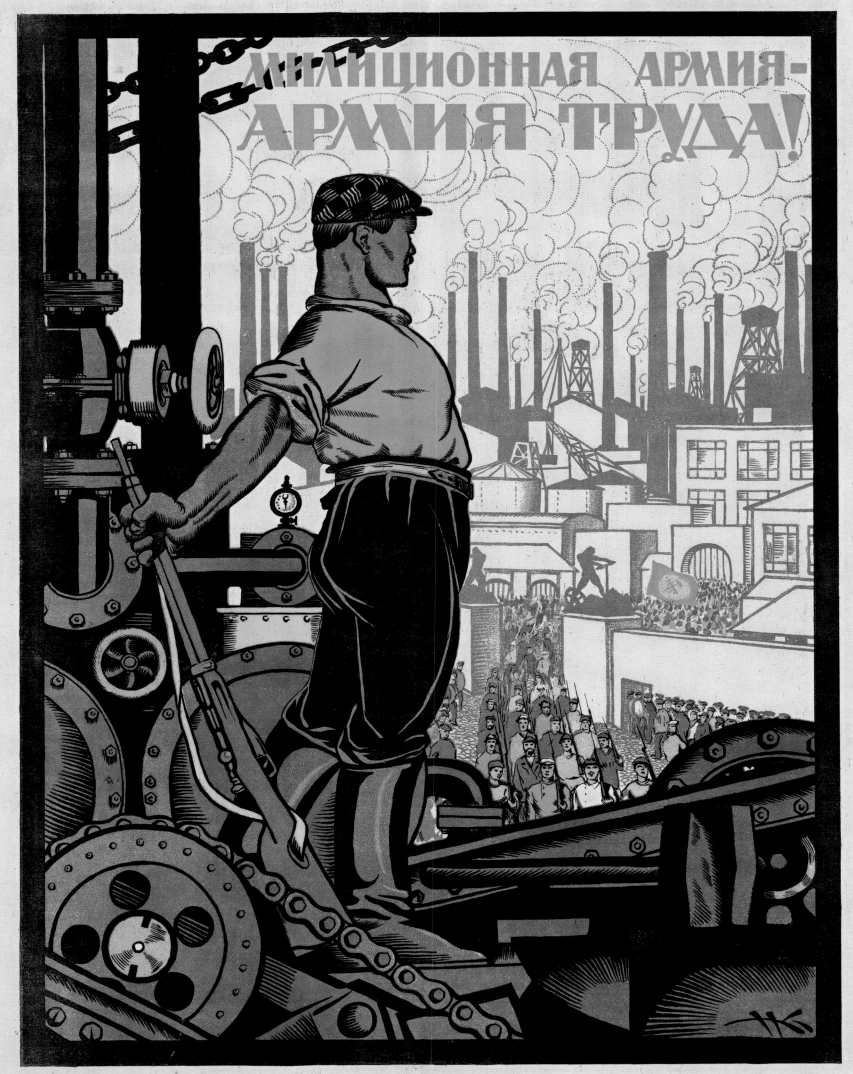

МИЛИЦИОННАЯ АРМИЯ —
АРМИЯ ТРУДА!

Литер.-Изд. Отдел Политуправления Р. В. С. Р. Типо-Литография М.Г.С.Н.Х.бывш И.М.Машистова. Библиотека Всевобуч. Москва, Арбат, 35.

ARTIST

Kochergin N. M.

TITLE

Militia Army — Army of Workers

YEAR

1920

SIZE

74 × 54 cm

The image of the worker is one of the iconic symbols used in Soviet posters. In this poster, the strong, fearless and dominating figure calls all workers of the young Soviet State to join the Militia Army — a reservist force composed of non-professional fighters who were called upon by the government to join combat whenever deemed necessary, which existed only in Soviet Russia. The poster was created in 1920, during the Civil War that took place from 1917 to 1922 between the Reds, the pro-Bolshevik army of Workers, and the Whites, the anti-Bolshevik forces. The imposing figure, pictured as though on top of the world, shows his fellow workers that they have become the principle ruling class of the Soviet Union, that the future of the country belongs to them and that at the end of the war they will go back to the factories to build their new country.

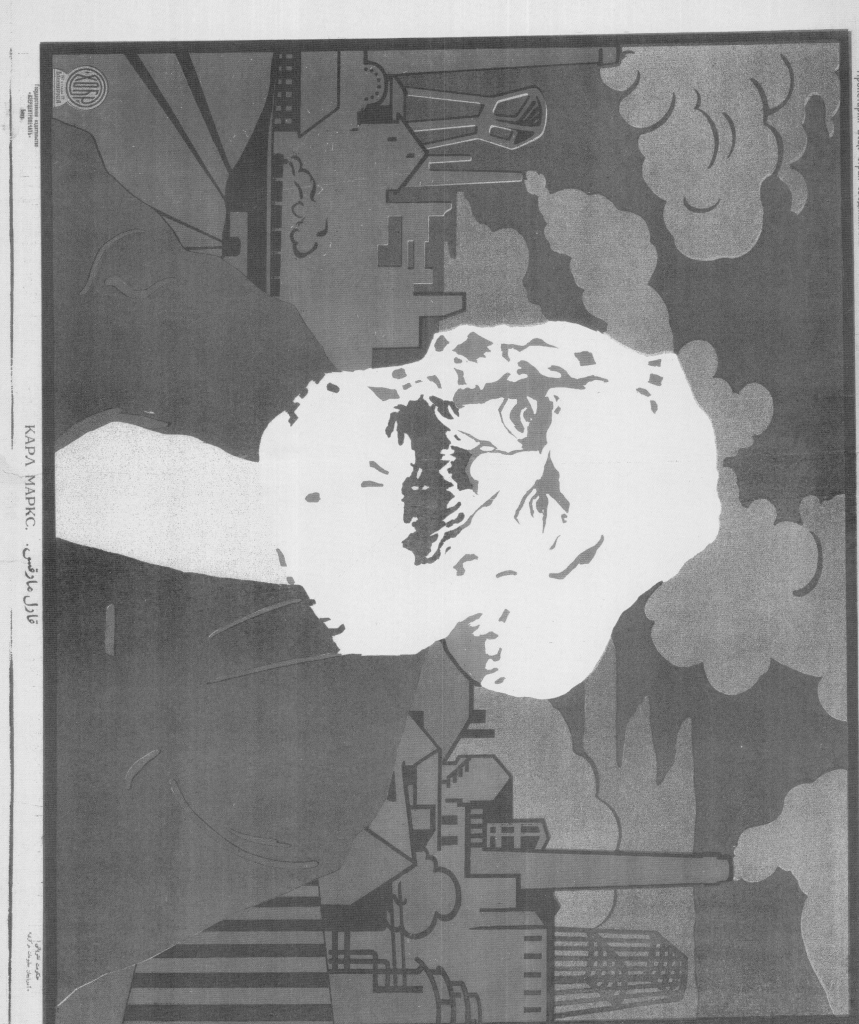

ARTIST
Unknown
TITLE
Karl Marx
YEAR
1920
SIZE
101 × 71 cm

The leading communist thinker, one of the major philosophers of the nineteenth century and one of the most influential figures in human history, Karl Marx is pictured at the centre of this poster. In the background, the artist depicts an industrialised urban and agricultural landscape. Numerous factories represent the development of the electric, petroleum and hydroelectric energy sectors, complete with vast fields, steam locomotives, housing constructions and smoking chimneys. This poster implies that the industrialisation and progress, and the new prosperity of the previously underprivileged working class, has only been possible thanks to the ideas of Marx, the founder of Communism. Without him, none of this would have happened.

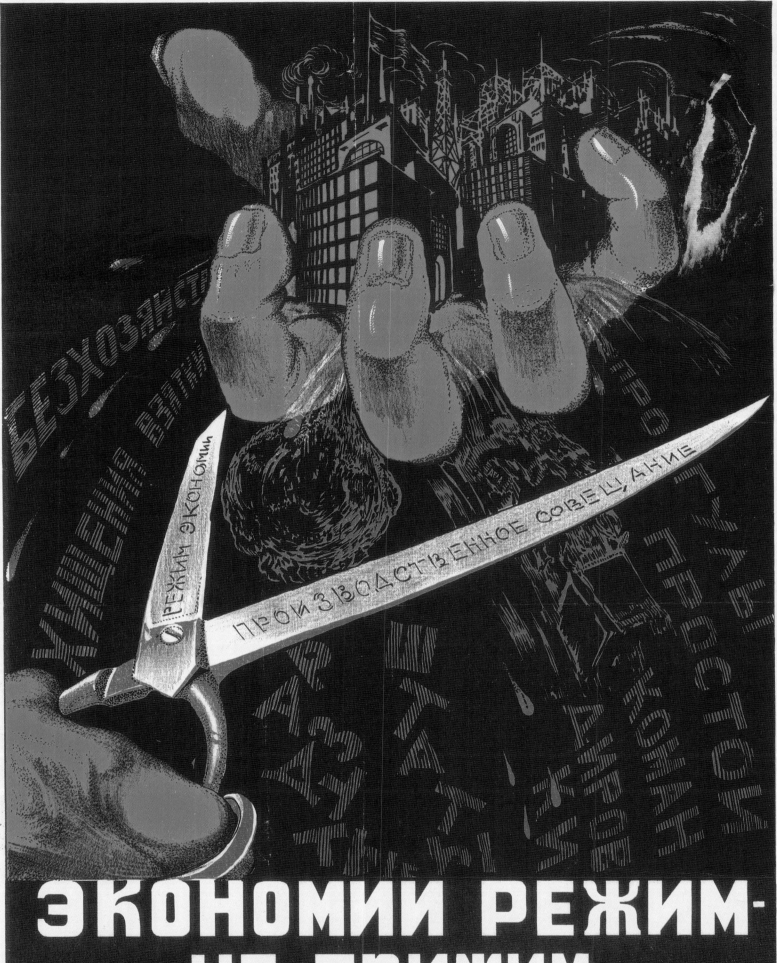

ЭКОНОМИИ РЕЖИМ —
НЕ ПРИЖИМ
ОН ЛИШЬ ТО И ОТСЕЧЕТ,
ЧТО МЕЖ ПАЛЬЦАМИ ТЕЧЕТ

Оригинал худ. Г. Алексеева. Главлит №75881. Тираж 5000. Издание Р. И. О. В. Ц. С. П. С. Типо-Литография В. Т. У. имени тов. ДУНАЕВА. Москва, Б. Полянка, 9.

ARTIST

Alekseev G. D.

TITLE

The New Savings Regime Does Not Mean Clamping Down on the Economy — It Only Cuts Down the Waste

YEAR

1927

SIZE

53.3 × 36 cm

This poster uses vivid colours to give it greater impact, with red as a symbol of positive force and the communist revolution. The flourishing economy and the bright industrial future are portrayed by red-coloured constructions in the robust red hand of revolutionary force. Another muscular red hand cuts them away from the evils of corruption, unemployment and unnecessary expenditure, which prevent the economy from developing. The scissors symbolise a new form of economic management, which marked the beginning of the period of Stalin's Five-Year Plans. According to the poster, reducing costs is not aimed at slowing the economy or progress, but rather at creating more efficient structures of management and administration. In reality, the standard of living had dropped and Stalin's strict laws to improve discipline at work only made the situation worse.

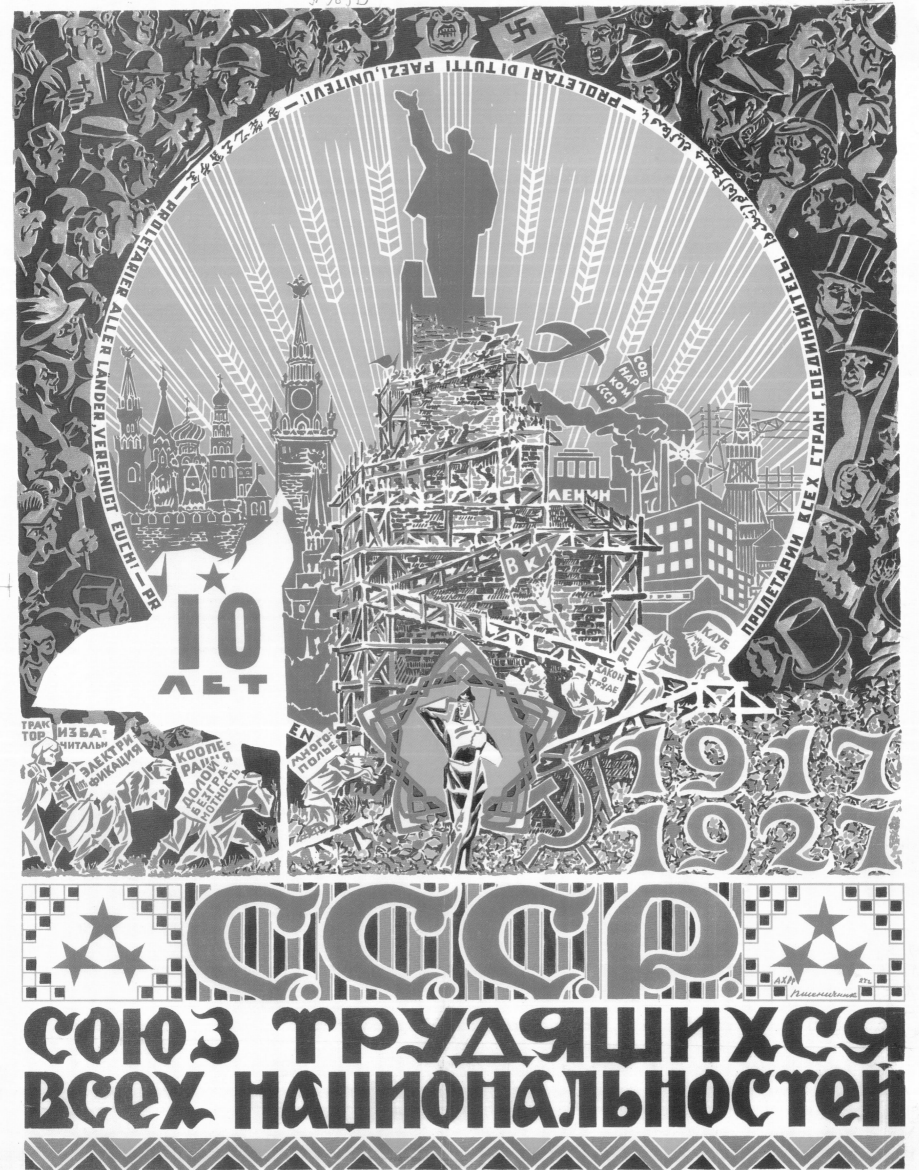

ARTIST

Pshenichnikov V. S.

TITLE

USSR — Union of Workers of All Nationalities

YEAR

1927

SIZE

73.5 × 54.5 cm

Printed in 1927, this poster celebrates the tenth anniversary of the Soviet Union. Russia is portrayed as a bright, shining sun in a world of darkness, confusion and aggression. Lenin stands at the centre of this sunlit universe, on top of an ambitious skyscraper project launched by Stalin but that was never completed. Lenin is depicted between the Kremlin towers, on the left, and booming factories, on the right, which symbolise industrialisation and development. The small red figures below carry slogans with important issues of the time — teaching the illiterate population to read and write, the collectivisation of lands and electrification of the country. The poster claims that Russia is a state of different nationalities who are finally happy under Communism, though, in reality, many of the Republics were forced into joining the Soviet Russia.

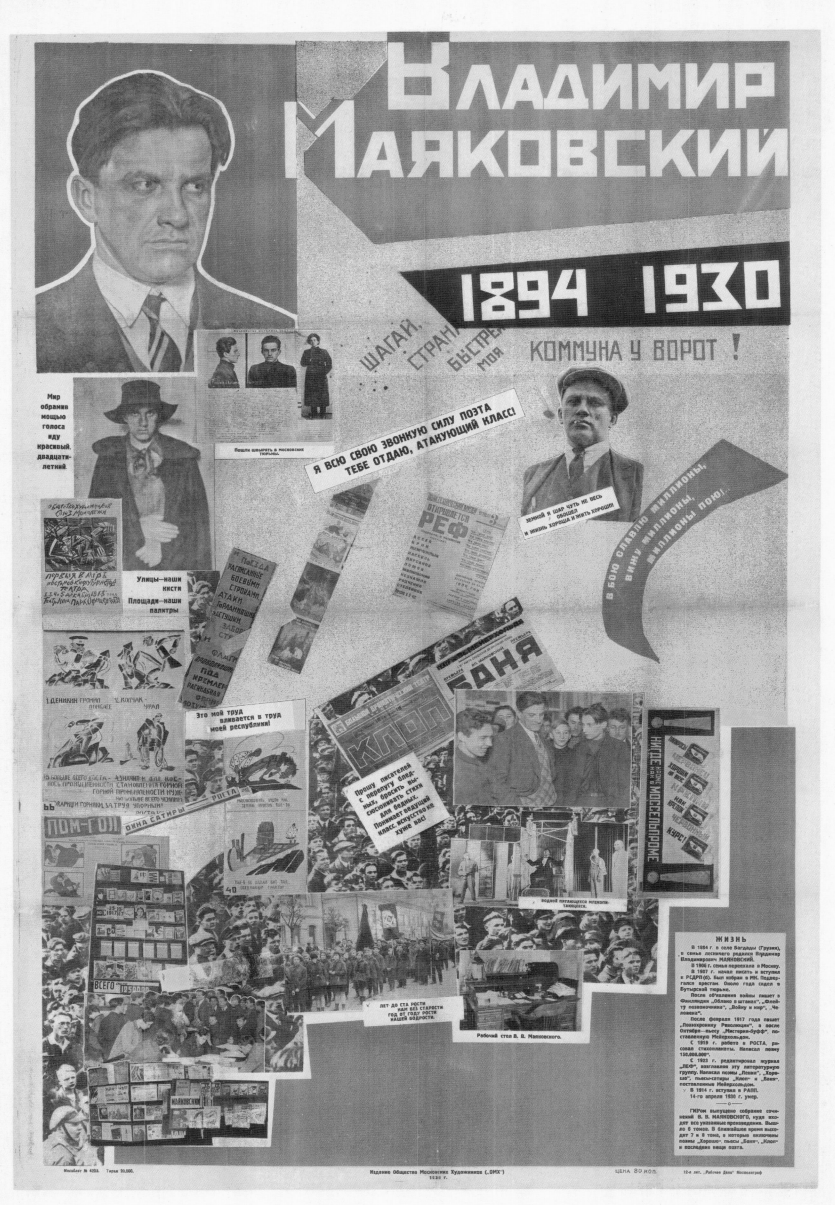

ARTIST

Rodchenko, A. M.

TITLE

Vladimir Mayakovsky, 1894-1930

YEAR

1930

SIZE

103 × 75 cm

Produced by Alexander Rochenko, the leading graphic designer and photographer, this poster commemorates the life of his friend Vladimir Mayakovsky, a famous Soviet poet. Created shortly after the poet's death, Rodchencko employs skilful and dynamic photomontage to create a poster that brings together various elements in celebration of Mayakovsky's life and work, whose name and dates of birth and death occupy the top right hand corner, with a portrait photograph to the left. The design features newspaper clippings and material from archives, which give an outline of his life: images highlight the poet's popularity with young workers and his ties to the working classes; some of the photographs were taken from a police file created during his imprisonment during Tsarist Russia; the caricatures were made by him for the Soviet Telegraph News Agency — ROSTA, which used drawings as the main means of communicating the Bolshevik version of events; and across the poster, lines from his revolutionary poems and images of his funeral procession and ceremony are also included.

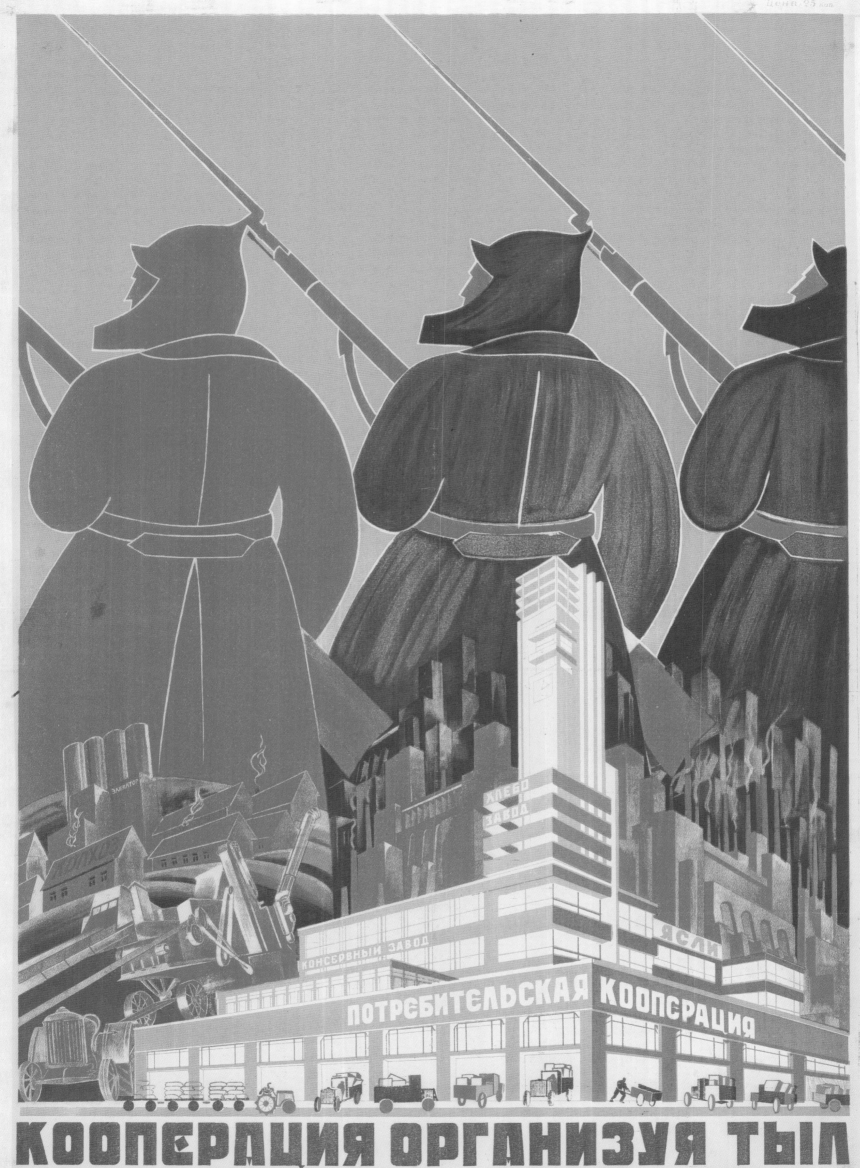

КООПЕРАЦИЯ ОРГАНИЗУЯ ТЫЛ
УКРЕПЛЯЕТ КРАСНУЮ АРМИЮ

ARTIST

Unknown

TITLE

Cooperation, Organising the Home Front, Strengthens the Red Army

YEAR

1930

SIZE

104 × 73 cm

This highly impressive poster uses contrasting colours to maximise its impact. The Red Army, towering over the world, is pictured above a white construction entitled 'Consumer Cooperative', which serves as the army's solid foundation. These cooperatives were organised to purchase products from peasants at wholesale prices. The poster relates to the beginning of the collectivisation period in Russia, during which labour and land were merged into collective farms, known as *kolkhozy*. The image implies that the united work and cooperation of peasants provides the necessary support for the Red Army to protect Russia from oppressors. In reality, peasants were reluctant to join *kolkhozy* and viewed collectivisation as a return to serfdom. The disruptions caused by collectivisation would eventually lead to the Great Famine in Ukraine from 1932-1933.

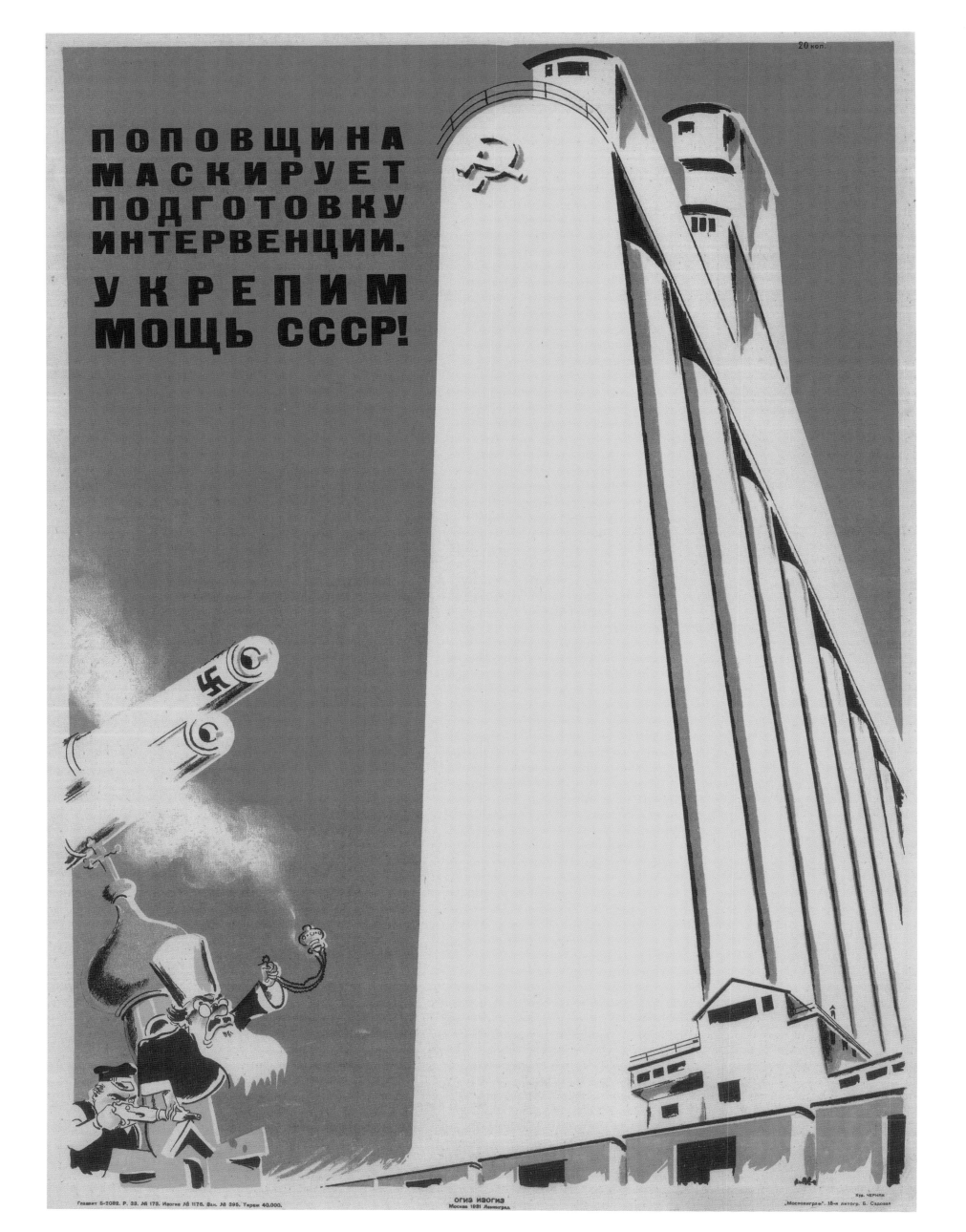

ARTIST

Chernyak R. M.

TITLE

Sacerdotalism is Hiding the Preparation of Intervention.
Let's Strengthen the Forces of the USSR

YEAR

1931

SIZE

71 × 51 cm

In this poster, Russia is depicted as an immense, invincible, modern and pure white construction — the fusion of a building and a hydroelectric power station, with a solid red base — that needs to be defended from the aggression of religion and fascism. A priest waves incense threateningly, while two enormous swastika adorned cannons point menacingly at the building. The poster dates from the 1930s, a period during which Stalin intensified his anti-religious stance, and while the priest is pictured as a small caricature, the poster warns that they can still be dangerous. Although outlawed after the revolution, religion remained popular more than ten years later. During Stalin's campaign, many members of the Orthodox church were killed or sent to labour camps, most churches were closed and laws forbade religious activities.

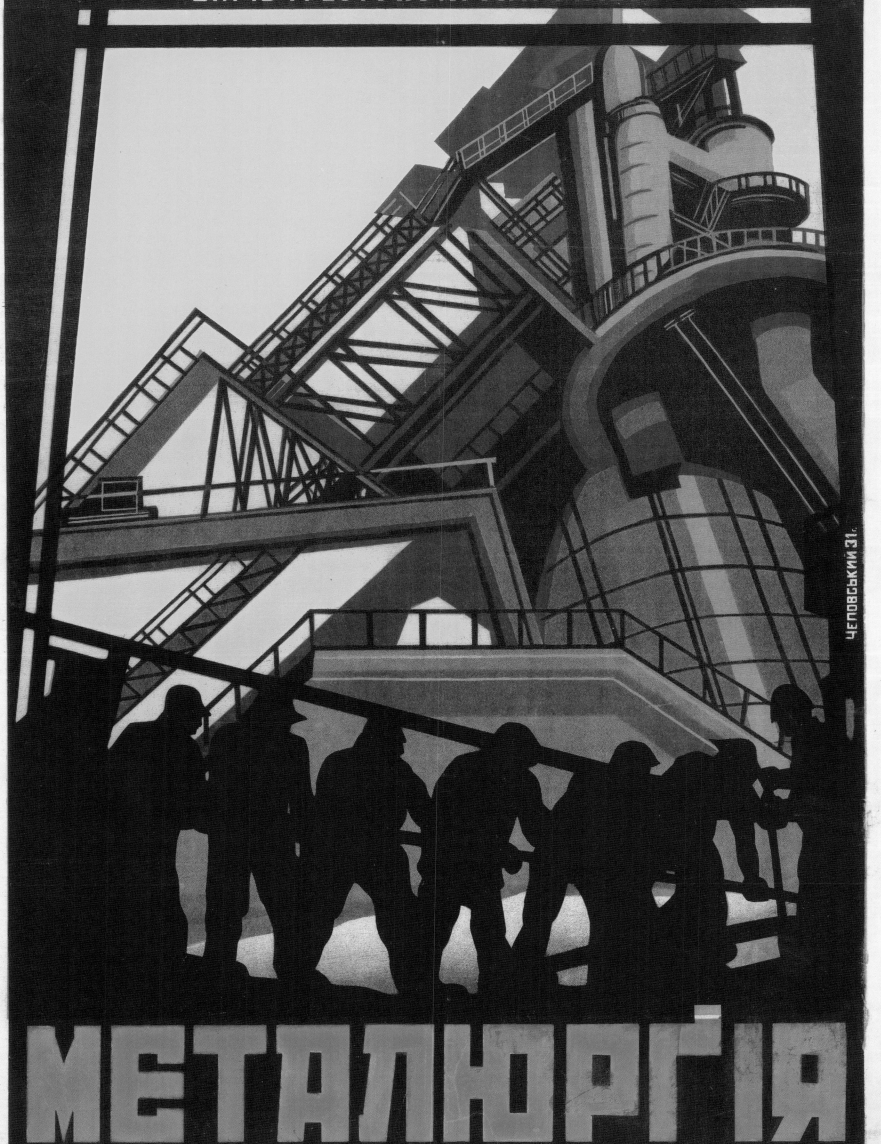

ARTIST

Chepovsky

TITLE

Metallurgy

YEAR

1931

SIZE

87.5 × 62.5 cm

The promotion of Five-Year Plans, introduced by Stalin to centralise the economy and increase industrial output, was a common theme in Soviet posters. Created in Ukraine, during the first Five-Year Plan from 1928-1933, this poster addresses one of the most pertinent subjects for the region — metallurgy. In the 1930s, Ukraine had experienced runaway growth thanks to the politics of developing heavy industry. In addition to the already existing metallurgical plants in the areas of Donetsk or Dnepropetrovsk, new works opened in Zaporozhie and Mariupol, in south-eastern parts Ukraine. The production of steel was of the utmost importance for industrial expansion; Russia was in locked in a constant and uneasy technological competition with the west. Factories needed a greater workforce and the poster, which was painted in the Ukrainian national colours of blue and yellow, calls on workers to join the metallurgy factories as employees.

ARTIST
Dolgorukov N. A.

TITLE
All Power Belongs to Unions!

YEAR
1932

SIZE
103 × 68.5 cm

This photomontage poster mixes art and reality by employing newspaper cut-outs, colours and drawings, which gives the poster a powerful simplicity. It portrays Lenin as the first citizen of Russia, who brought freedom and equality to the people and made it possible for the unions to become the principle force in the country. Progress, industrialisation and electrification, symbolised by the factories and DniproHES, Dnieper Hydroelectric Station completed in 1932 in Ukraine, have been achieved thanks to their work. The poster reminds the spectator that the fight for equality had been going on since the 1871 Paris Commune, during which a group of socialists seized control of Paris for a few months. Freedom had finally been achieved after years of fighting, thanks to Lenin, which made citizens very proud of their leader. The Bolshoi Theatre, depicted in the upper left hand side of the poster, could give this poster another meaning, possibly implying that the artist sees it all as a show to cover up the oppression of the Red Terror.

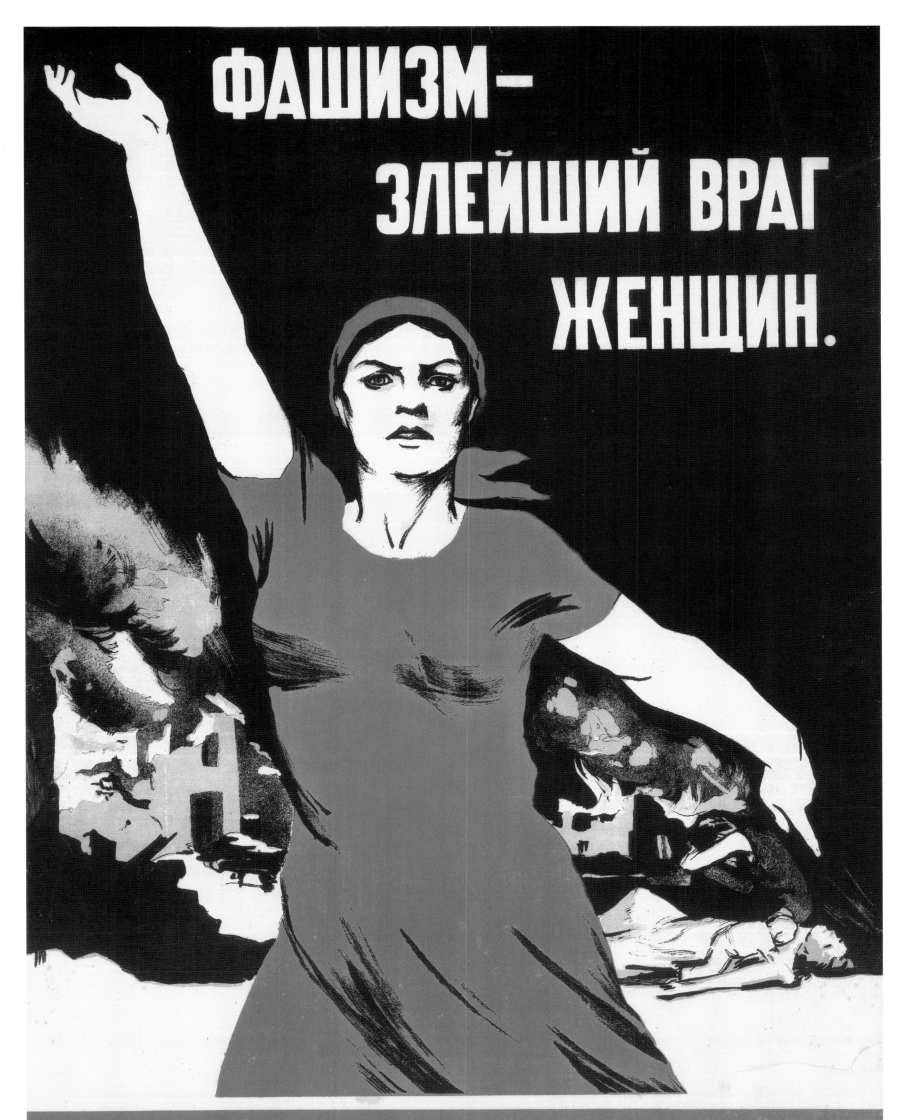

ФАШИЗМ – ЗЛЕЙШИЙ ВРАГ ЖЕНЩИН.

ВСЕ НА БОРЬБУ С ФАШИЗМОМ!

ARTIST

Vatolina N. N.

TITLE

Fascism is the Worst Enemy of Women! Rise Up and Fight It!

YEAR

1941

SIZE

86 × 58 cm

This poster is one of the most important from the Second World War period. Nina Vatolina, who created numerous other famous works, produced this poster in 1941, just a few months after Russia entered the war. Within a short time, Hitler had conquered large swathes of Russian territory and was getting dangerously close to Moscow. Vatolina employs a motif used extensively during the war, that of the woman as protector of Russia and mother of the soldiers. Women were also the primary workforce in factories during this period, with the majority of the men fighting at the front. Dressed in a bright red dress, mirroring the red colour of the flag of the Soviet Union, the powerful figure calls on everyone to fight the fascists, murderers of women and children.

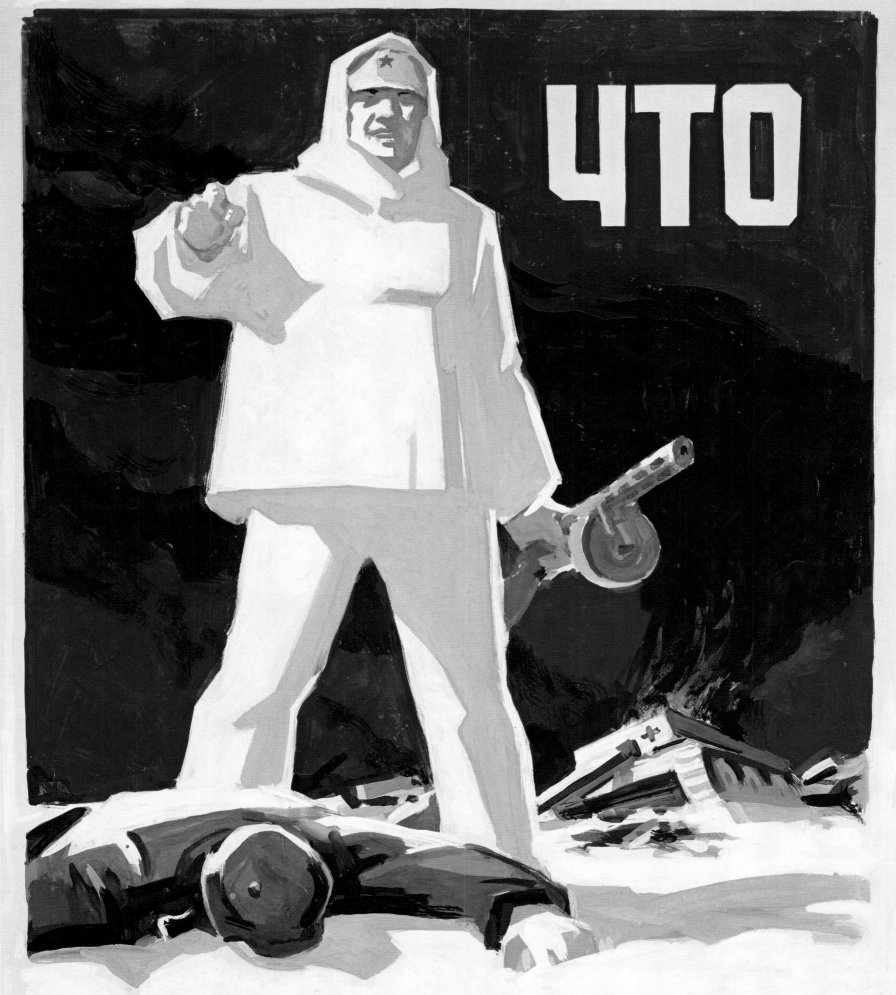

ARTIST

Berngard O. E.

TITLE

What Have You Done Today to Win?

YEAR

1942

SIZE

86 × 61 cm

Printed in 1942, this poster marks the decisive year for Russia in the Second World War, during which Soviet troops won the battle of Stalingrad, a turning point in the war on the Eastern Front, from which German troops began to retreat. It was also the year in which the *Big Three*, the leaders of Britain, Russia and the U.S.A., began to control allied policy. The poster addresses the civilian population, calling on them to work for the needs of the front line, telling them that not one day should go by without helping their soldiers to victory. The poster aims to remind people that if the work of the civilian population is difficult, with low rations of bread and no heat or electricity, it remains nonetheless easier than that of a soldier, whose life at the front is not only difficult but dangerous.

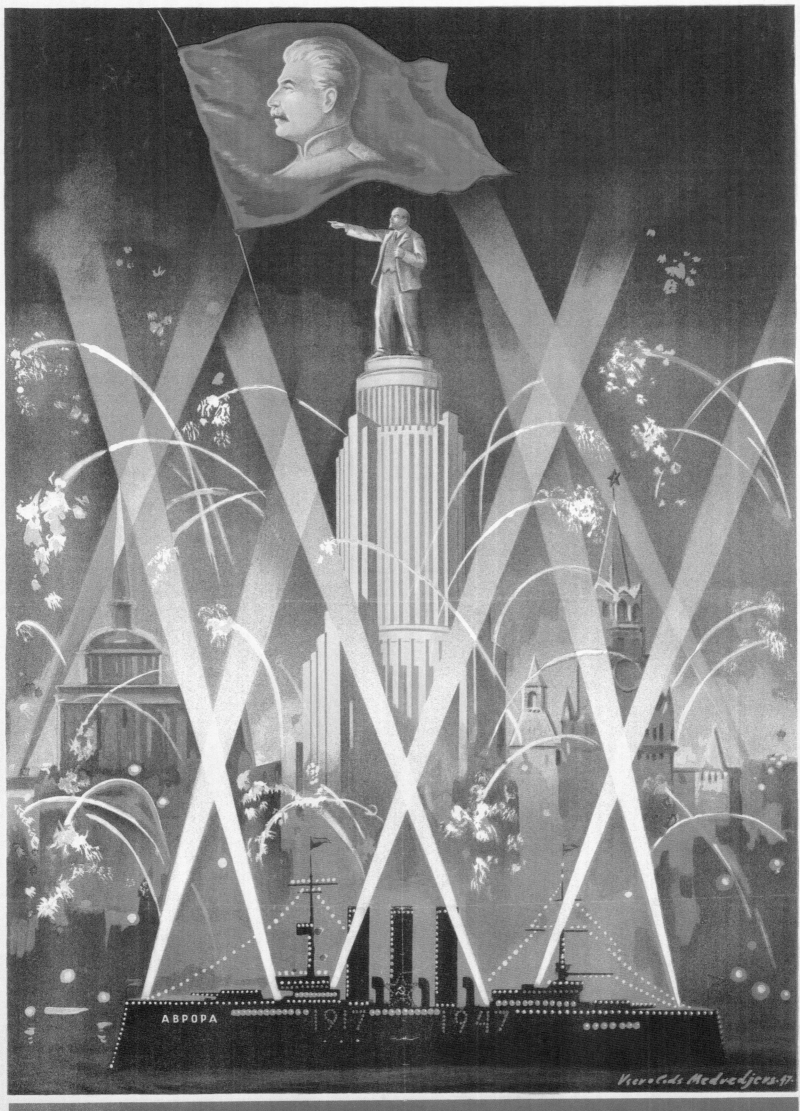

АВРОРА 1917 1947

ДА ЗДРАВСТВУЕТ XXX ГОДОВЩИНА ВЕЛИКОЙ
ОКТЯБРЬСКОЙ СОЦИАЛИСТИЧЕСКОЙ РЕВОЛЮЦИИ!

ARTIST

Medvedev V.

TITLE

**Happy XXX Anniversary of the Great October
Socialist Revolution!**

YEAR

1947

SIZE

102 × 68 cm

A celebration of the thirtieth anniversary of the revolution, this poster contains the main symbols of revolutionary Russia: an impressive statue of Lenin looms large in the centre, on top of the Palace of Soviets — a monumental building project launched by Stalin that was never completed — while a banner of Stalin flies overhead, one of the Kremlin towers stands on the right and the cruiser Aurora lights the scene from below. The Kremlin symbolises Moscow — the capital of Russia — and the Aurora had become an icon of the revolution: on 25th October 1917 at 9.45 PM, its sailors fired a blank shot from its forecastle gun, signalling the start of the assault on the Winter Palace, the residence of the Russian Tsars, and marking the beginning of the October Revolution. The cruiser was quickly turned into a museum, which people were obliged to visit during official tours of Saint Petersburg (or Leningrad, as it was known after 1924), and was commemorated in numerous songs, films and literature.

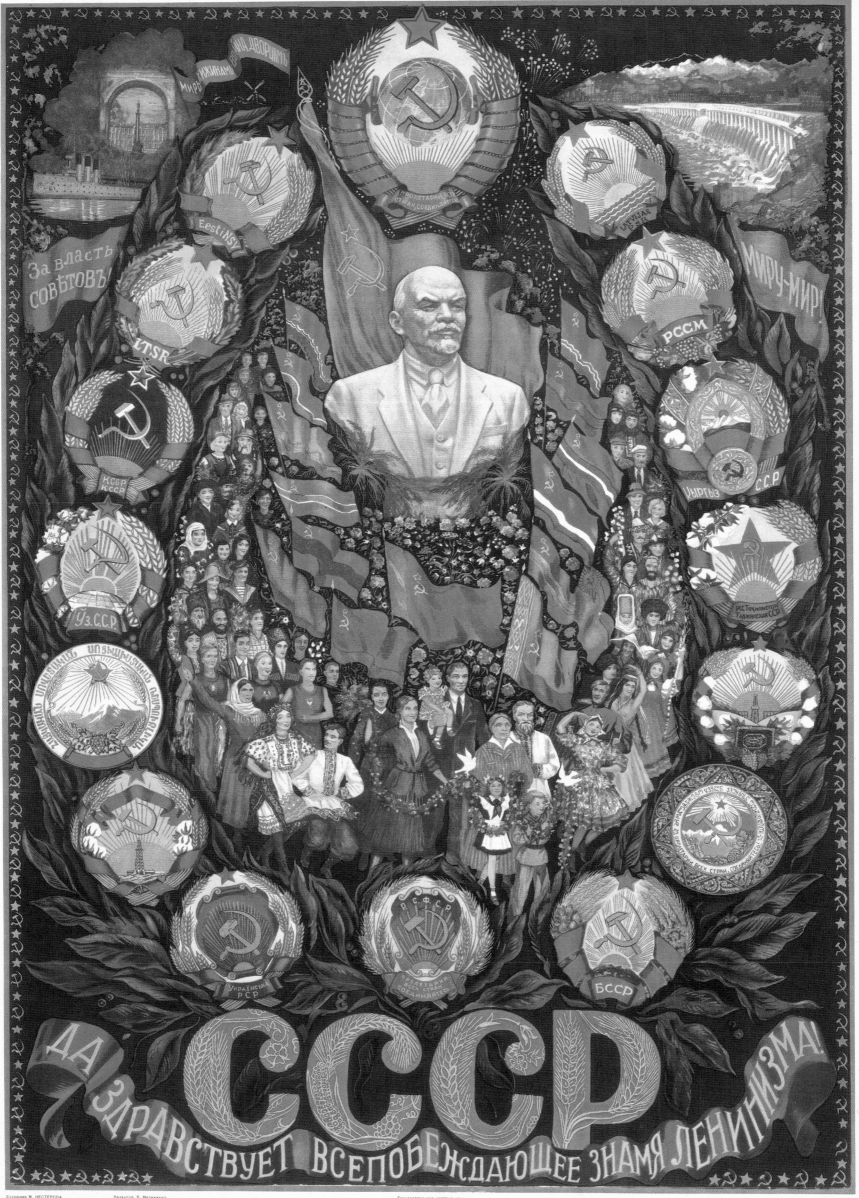

ARTIST

Nesterova (Nesterova-Berzina), M. A.

TITLE

Long Live the Conquering Banner of Leninism! USSR

YEAR

1957

SIZE

81 × 56 cm

This bright and vivid poster depicts the splendour of Soviet Russia. The strength and unity of the Soviet Union is portrayed by the fifteen Soviet Republics (anticlockwise from top left: Estonia, Lithuania, Kazakhstan, Uzbekistan, Azerbaijan, Armenia, Ukraine, Russia, Belarus, Georgia, Turkmenistan, Tajikistan, Kyrgyzstan, Moldova and Latvia). The grandeur of the Union is shown through the many elements of the poster: the emblems of each state and their representatives, dressed in bright national costumes; the icon of the revolution, the cruiser Aurora, and a view of Saint Petersburg in the top-left corner; and DniproHES, the Dnieper Hydroelectric Power Station in Ukraine, the largest in Europe at the time, in the top-right corner. The whole image is wrapped in a laurel wreath, a symbol of victory, and fireworks explode above the central image of Lenin, the father of the Soviet state.

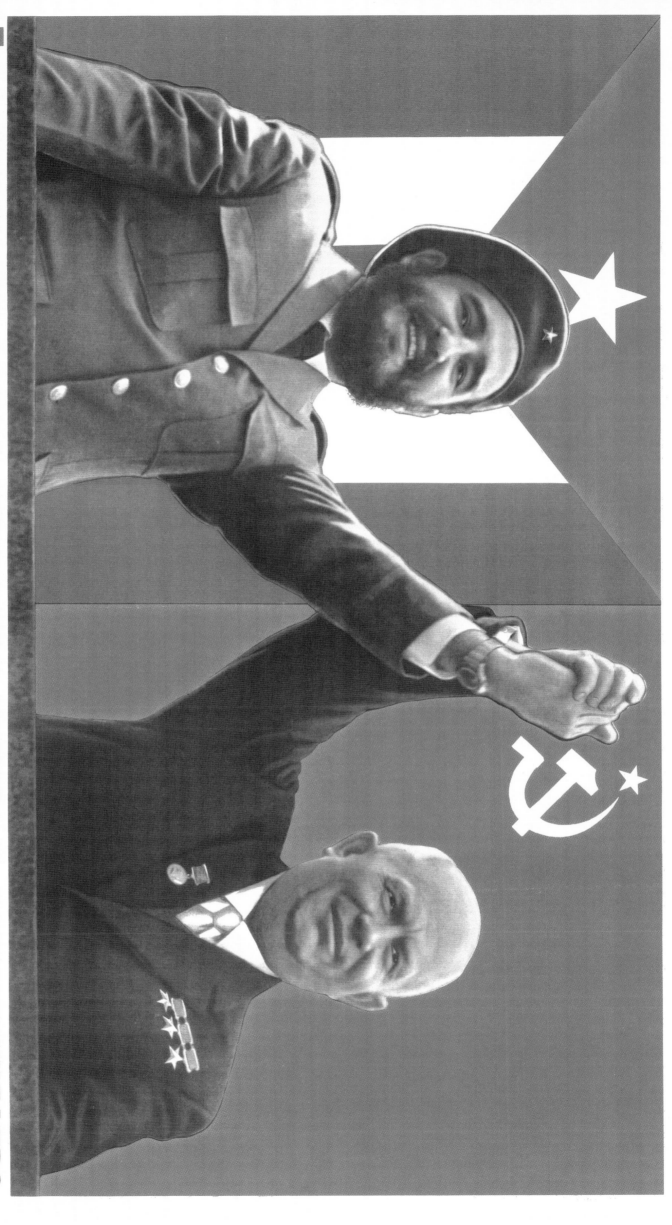

ДА ЗДРАВСТВУЕТ ВЕЧНАЯ, НЕРУШИМАЯ ДРУЖБА И СОТРУДНИЧЕСТВО МЕЖДУ СОВЕТСКИМ И КУБИНСКИМ НАРОДАМИ!

ARTIST

Gurary S. M., Kershin Y. V..

TITLE

Khrushchev and Fidel

YEAR

1963

SIZE

58 × 89 cm

Produced a year after the Cuban missile crisis, during which Fidel Castro and Nikita Krushchev secretly agreed to place Soviet missiles aimed at the U.S.A. on Cuba. The poster depicts the Cuban-Soviet friendship. The poster serves a number of purposes, on one hand it emphasises the importance of Cuba as a strategic partner in international politics, on the other it reminds Russian workers that Communism is present in all parts of the world and that Russia is not alone. In the 1960s, the Russian people had stopped believing in the imminent worldwide victory of Communism and their own country's prosperity. The artist depicts both leaders standing atop Lenin's Mausoleum on Red Square — a place reserved for the 'happy few', primarily the nation's leaders during state occasions and military parades — enthusiastically greeting the people with their flags in the background, as though encouraging the disillusioned proletariat.

ARTIST

Kershin U. V. and Nadezhdin G. P.

TITLE

Glory to the First Woman Cosmonaut!

YEAR

1963

SIZE

57.5 × 86 cm

The heroine of the poster, Valentina Tereshkova, was the first woman in space. She was selected from four hundred candidates, not least for her proletarian background. Hailing from a simple family of workers, she became a national hero and had an impressive career in the male-dominated Soviet government, providing an example of everything that a woman could achieve in the Soviet Union. Not many people knew that the flight did not go well –Tereshkova experienced much physical discomfort during the trip and the Russian government decided to dissolve the pioneering group of female cosmonauts. It would take 19 years for Svetlana Savitskaya to follow in Tereshkova's footsteps and become the second Russian woman in space. This poster aims to show the values and achievements of the Soviet Union are only possible in a communist state.

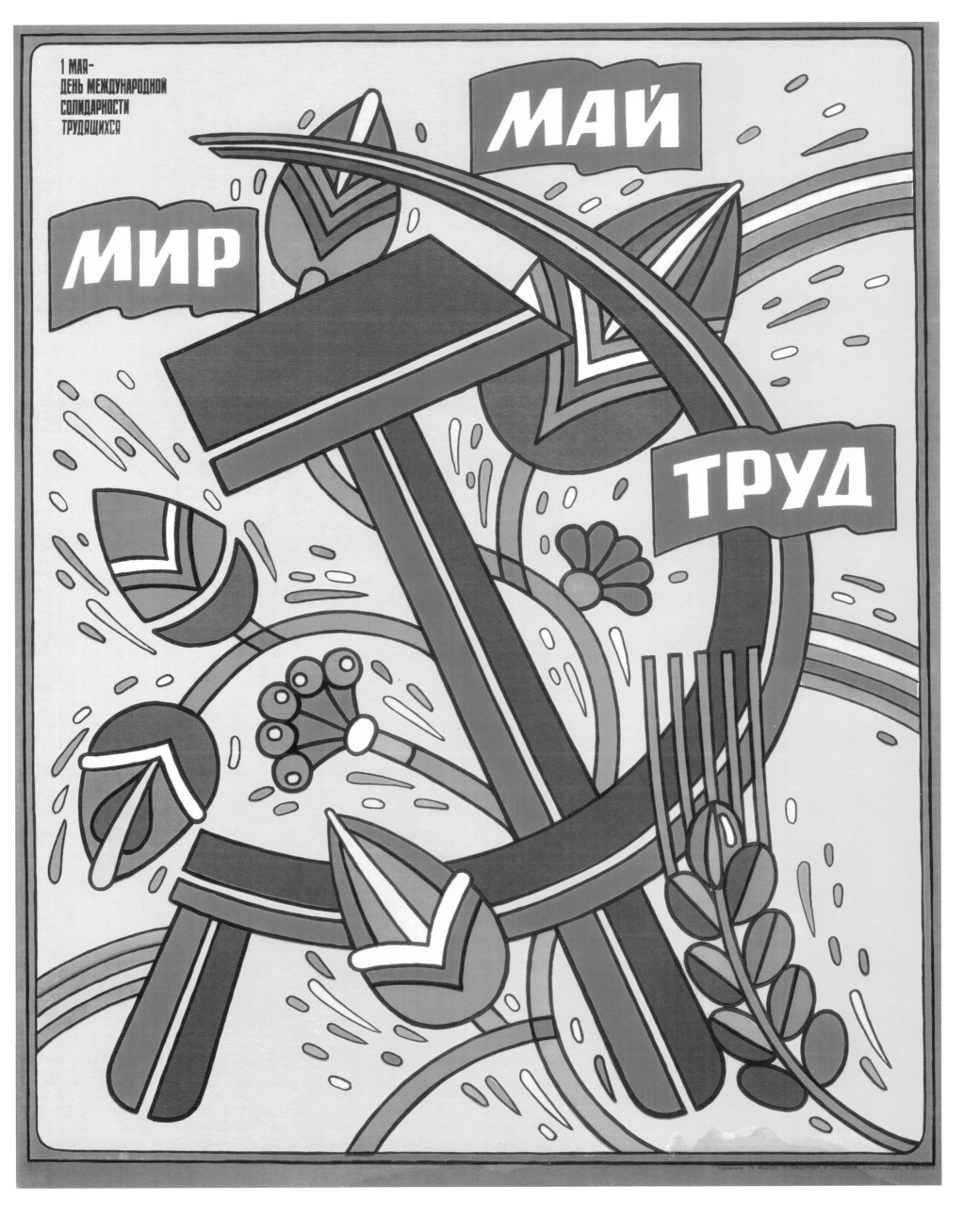

ARTIST

**Feklyaev V. N., Ivanov K. K., Karakashev V. S.,
Levshunova L. Y. and Lukyanov M. V.**

TITLE

1st May

YEAR

1980

SIZE

55 × 42.5 cm

1st May is a late example of the Soviet propaganda poster, the production of which would cease with *perestroika*. Unlike earlier posters, this one does not promise the impending worldwide victory of Communism or the prosperity of Russia. There are no portraits of Lenin or Karl Marx, which were often associated with the upcoming triumph. Instead, this colourful, cheery and masterfully painted poster displays the main symbols of the Soviet Union, the hammer and sickle, together with a sheaf of wheat, symbolising peace. It marks the most important holiday for workers, Labour Day, which celebrated their achievements, with the words "Peace, Work, May". The poster underlines that peace and work are the most important values in society and that these have been successfully achieved in the Soviet Union. By creating an 'atypical' and 'modern' poster, the artist makes an attempt to make communist values attractive to young people.

ВЗГЛЯД
НА МИР
ИЗ-ЗА
ОКЕАНА

ARTIST

Kazhdan E. A.

TITLE

Looking at the World from the Ocean

YEAR

1980

SIZE

65.5 × 48 cm

Uncles Sam's top-hat, black tie and white gloves — typical attributes of a bourgeois life-style — this is how Russia viewed its principal enemy, the U.S.A., during the Cold War. This obviously dangerous caricature of capitalist society observes the rest of the world from afar through its binoculars, ready to put the handcuffs of capitalism on its enemies at the first opportunity. The light blue colour of the glasses represents how the U.S.A. wants to be seen by others - pure and clear. The creator of the poster contrasts the image the U.S.A. wants to project and what they really are, revealing the true nature of Russia's powerful enemy. The poster aims to justify the government's increased military expenditure, which prevented them from spending money on industrial development and caused further economic stagnation.

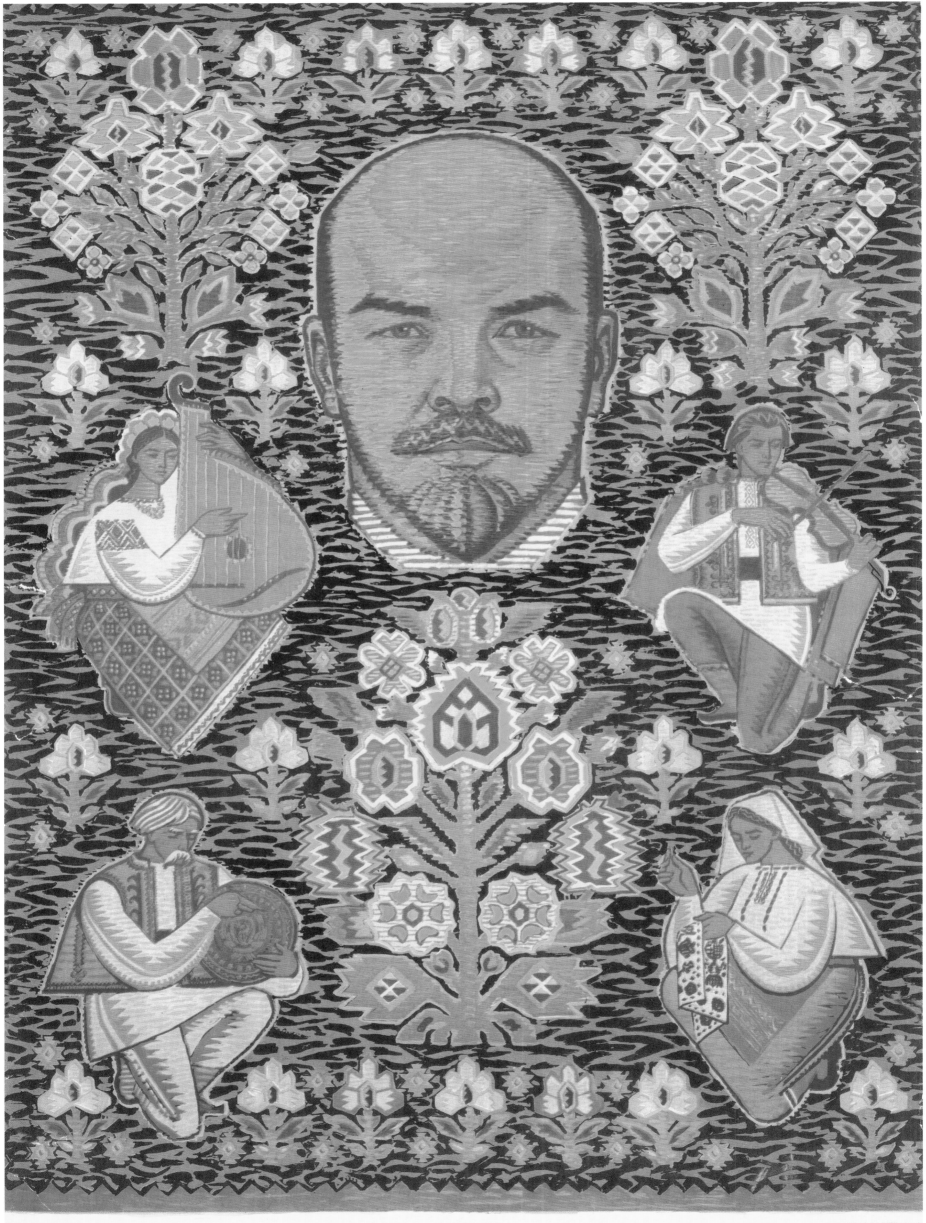

ARTIST

S. P. Kirichenko and N. G. Klein.

TITLE

A Song About Lenin

YEAR

Unknown

SIZE

100 × 72 cm

A Song about Lenin was created by two Ukrainian artists, Stepan Kirichenko and Nadezhda Klein, who were known for their paintings and mosaics that promoted the national values of Ukraine. The principal colours of the composition, blue and yellow, are the national colours of Ukraine, which symbolise the blue sky and yellow wheat fields. The centrally placed portrait of Lenin is surrounded by four artists dressed in traditional folk costumes — a tunic, apron and skirt for women, and trousers, a white shirt and boots for men. Three of the figures are shown playing traditional Ukrainian folk instruments, a bandura, tambourine and violin, and one of the women is cross-stitching an ornate white and red towel, which emphasises the importance of embroidery in Ukrainian art. The bouquets, formed of *mal'va* (mallow) and *barvinok* (periwinkle), among other things, symbolise love for the land, as well as eternity and the well-being of communist Ukraine.

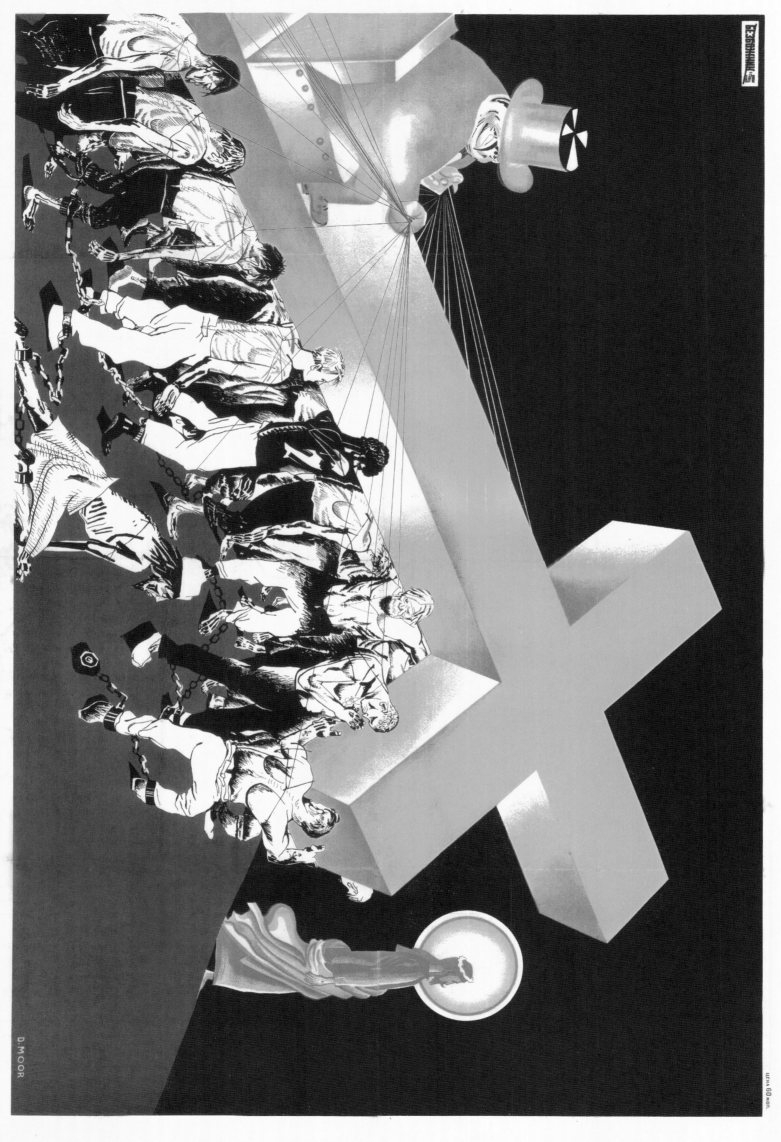

D.MOOR

ARTIST

Moor (Orlov) D. S.

TITLE

The Triumph of Christianity

YEAR

Unknown

SIZE

72.7 × 107.8 cm

The Triumph of Christianity is an early poster by the famous artist Dmitriy Orlov, who went by the professional name D. Moor. The poster aims to show workers that religion, the church and capitalism are all the same thing, and that capitalists use religion to make workers work harder for more hours and less pay, keeping them in the dark about their rights as humans, who can enjoy and profit from their lives and prosper thanks to humanity's achievements. D. Moor uses contrasting colours to give the image power and he depicts an overweight capitalist being carried on top of an oversized, heavy, gold cross by a group of exhausted workers. Only capitalists and religion gain from this arrangement, the poster implies, which calls on workers to rebel and free themselves from this oppression.